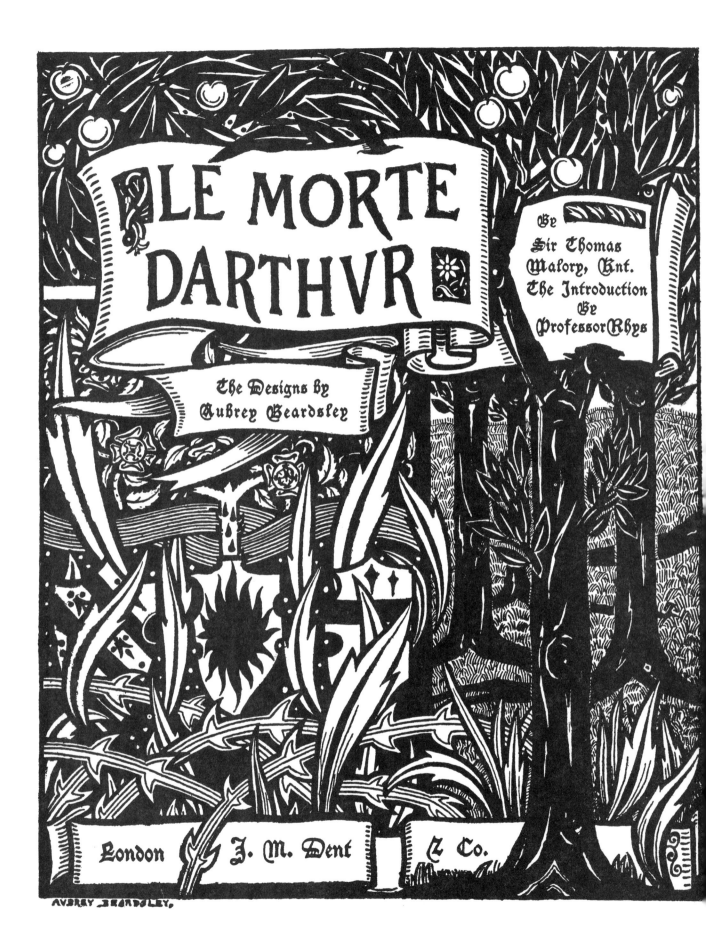

LE MORTE DARTHVR

By Sir Thomas Malory, Knt. The Introduction By Professor Rhys

The Designs by Aubrey Beardsley

London J. M. Dent & Co.

AUBREY BEARDSLEY,

BEARDSLEY'S
LE MORTE DARTHUR
SELECTED ILLUSTRATIONS

AUBREY BEARDSLEY

DOVER PUBLICATIONS, INC.
MINEOLA, NEW YORK

PUBLISHER'S NOTE

In 1892, Aubrey Beardsley was a 20-year-old art student who spent his lunch hours browsing in a bookshop. His work had been published only in school magazines.

Nevertheless, on the basis of some sketches and a sample frontispiece, the publisher J. M. Dent commissioned Beardsley to illustrate the *Morte Darthur* "in the manner of Burne-Jones" for the sum of 250 pounds. Beardsley thought it would require about 400 black-and-white drawings; the book was to be issued in monthly parts, the first to appear in one year.

The first issue appeared 18 rather than 12 months later, and Beardsley worked a full year beyond that as his projected 400 drawings grew to nearly 585 chapter openings, borders, initials, ornaments and other drawings, including 20 full- or double-page illustrations. When one considers that Beardsley, a consumptive, was already ill and also responsible during this period for his *Salomé* and the editorship of *The Yellow Book*, his productivity on the *Morte Darthur* seems all the more astonishing. This was undoubtedly Beardsley's greatest period: he entered it unknown, and ended it one of the most celebrated figures in London.

Beardsley seems an odd choice to have illustrated Malory—he was a modern satirist, not a Victorian medievalist. While Beardsley was able to imitate Burne-Jones's style, he was also much influenced by the look of the Japanese prints then so much in vogue among European artists and designers. The result is a Malory such as the world had never seen, with fauns and satyrs peering from behind the trees, and greater nudity and sexual frankness than one associates with any Victorian style.

Dent's *Le Morte Darthur* appeared in 12 parts in 1893 and 1894. It had only modest success. It was nevertheless a superb example of the illustrated book, and the work that launched the "Beardsley look" which changed the appearance of the *fin de siècle* and influenced succeeding generations, including our own.

The present volume contains a selection of 62 of Beardsley's drawings, including full-page illustrations, chapter openings and decorations.

Copyright

Copyright © 2001 by Dover Publications, Inc.
All rights reserved under Pan American and International Copyright Conventions.

Published in Canada by General Publishing Company, Ltd., 895 Don Mills Road, 400-2 Park Centre, Toronto, Ontario M3C 1W3.
Published in the United Kingdom by David & Charles, Brunel House, Forde Close, Newton Abbot, Devon TQ12 4PU.

Bibliographical Note

This Dover edition, first published in 2001, is a new selection of art and pages from Sir Thomas Malory, *Le Morte Darthur*, published by J.M. Dent & Co., London, in 1893–1894.

Library of Congress Cataloging-in-Publication Data

Beardsley, Aubrey, 1872–1898.
 Beardsley's Le Morte Darthur : selected illustrations / Aubrey Beardsley.
 p. cm.
 "Dover edition, first published in 2001, is a new selection of art and pages from Sir Thomas Malory, Le Morte Darthur, published by J.M. Dent & Co., London, in 1893–1894."
 ISBN 0-486-41795-6 (pbk.)
 1. Beardsley, Aubrey, 1872–1898. 2. Malory, Thomas, Sir, 15th cent. Morte d'Arthur—Illustrations. 3. Arthurian romances—Illustrations. I. Title.
NC978.5.B43 A4 2001
741.6'4'092—dc21

2001037123

Manufactured in the United States of America
Dover Publications, Inc., 31 East 2nd Street, Mineola, N.Y. 11501

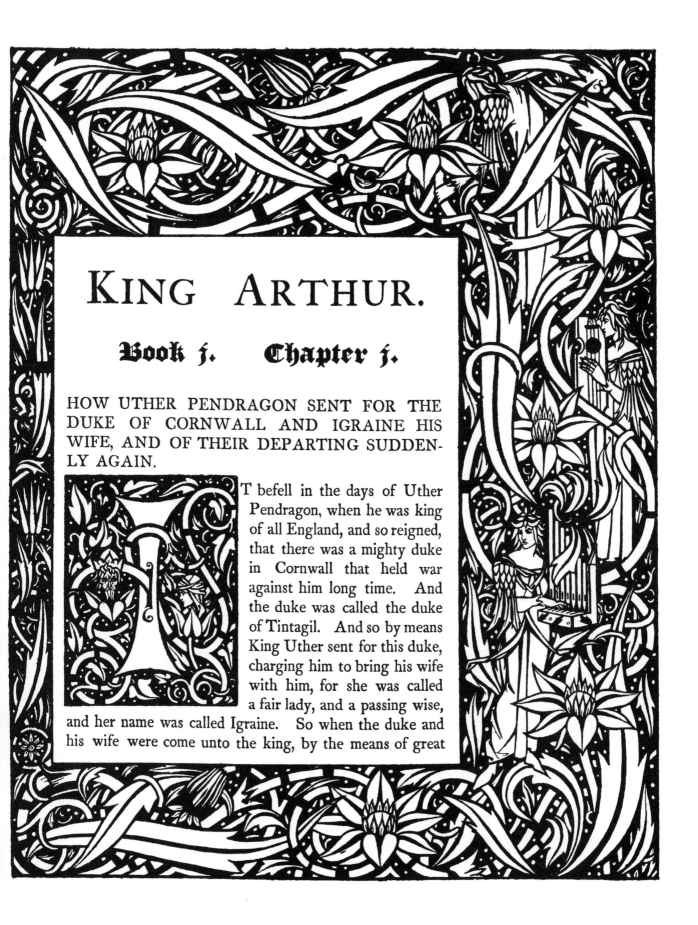

KING ARTHUR.

Book j. Chapter j.

HOW UTHER PENDRAGON SENT FOR THE DUKE OF CORNWALL AND IGRAINE HIS WIFE, AND OF THEIR DEPARTING SUDDENLY AGAIN.

T befell in the days of Uther Pendragon, when he was king of all England, and so reigned, that there was a mighty duke in Cornwall that held war against him long time. And the duke was called the duke of Tintagil. And so by means King Uther sent for this duke, charging him to bring his wife with him, for she was called a fair lady, and a passing wise, and her name was called Igraine. So when the duke and his wife were come unto the king, by the means of great

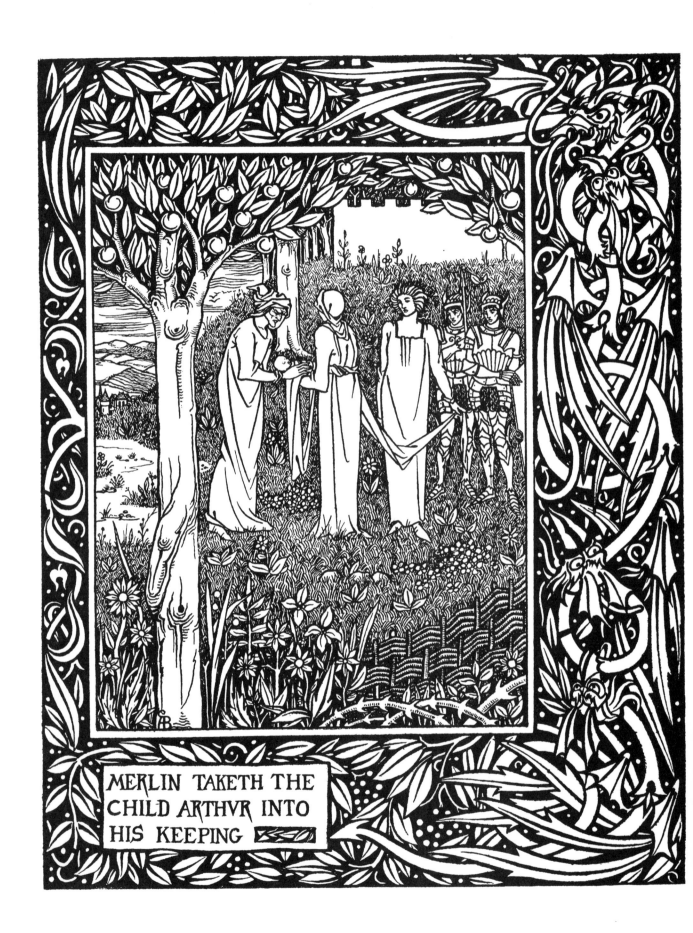

MERLIN TAKETH THE
CHILD ARTHVR INTO
HIS KEEPING

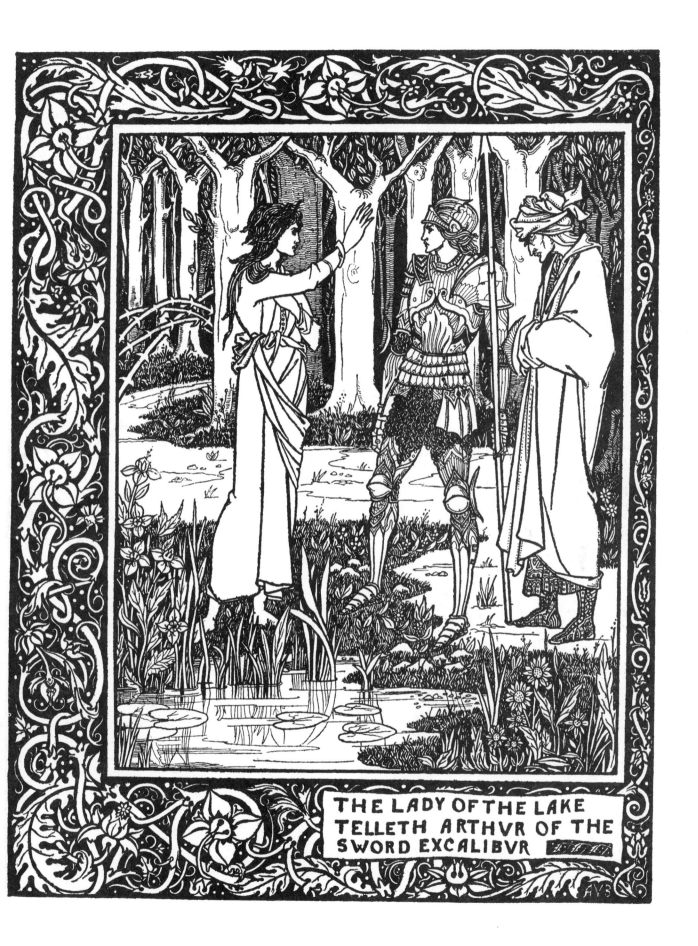

THE LADY OF THE LAKE
TELLETH ARTHVR OF THE
SWORD EXCALIBVR

Book ij. Chapter j.

OF A DAMOSEL WHICH CAME GIRT WITH
A SWORD FOR TO FIND A MAN OF SUCH
VIRTUE TO DRAW IT OUT OF THE SCABBARD.

AFTER the death of Uther Pendragon reigned Arthur his son, the which had great war in his days for to get all England into his hand. For there were many kings within the realm of England, and in Wales, Scotland, and Cornwall. So it befell on a time when King Arthur was at London, there came a knight and told the king tidings how that the King Rience of North Wales had reared a great number of people, and were entered into the land, and burnt and slew the king's true liege people. If this be true, said Arthur, it were great shame unto mine estate but that he were mightily withstood. It is truth, said the knight, for I saw the host myself. Well, said the king, let make a cry, that all the lords, knights, and

Book iij. Chapter j.

HOW KING ARTHUR TOOK A WIFE, AND
WEDDED GUENEVER, DAUGHTER TO LEODE-
GRANCE, KING OF THE LAND OF CAMELIARD,
WITH WHOM HE HAD THE ROUND TABLE.

N the beginning of Arthur, after
he was chosen king by adventure
and by grace; for the most part
of the barons knew not that he
was Uther Pendragon's son, but
as Merlin made it openly known.
But yet many kings and lords
held great war against him for
that cause, but well Arthur
overcame them all, for the most
part the days of his life he was
ruled much by the counsel of
Merlin. So it fell on a time
King Arthur said unto Merlin, My barons will let me have
no rest, but needs I must take a wife, and I will none take
but by thy counsel and by thine advice. It is well done,
said Merlin, that ye take a wife, for a man of your bounty

Book iv. Chapter j.

HOW MERLIN WAS ASSOTTED AND DOATED ON ONE OF THE LADIES OF THE LAKE, AND HOW HE WAS SHUT IN A ROCK UNDER A STONE AND THERE DIED.

SO after these quests of Sir Gawaine, Sir Tor, and King Pellinore, it fell so that Merlin fell in a dotage on the damosel that King Pellinore brought to court, and she was one of the damosels of the lake, that hight Nimue. But Merlin would let have her no rest, but always he would be with her. And ever she made Merlin good cheer till she had learned of him all manner thing that she desired; and he was assotted upon her, that he might not be from her. So on a time he told King Arthur that he should not dure long, but for all his crafts he should be put in the earth quick, and so he told the king many things that should befall, but always he warned the king to keep well his sword and the scabbard, for he told him how the sword and the scabbard should be stolen by a woman

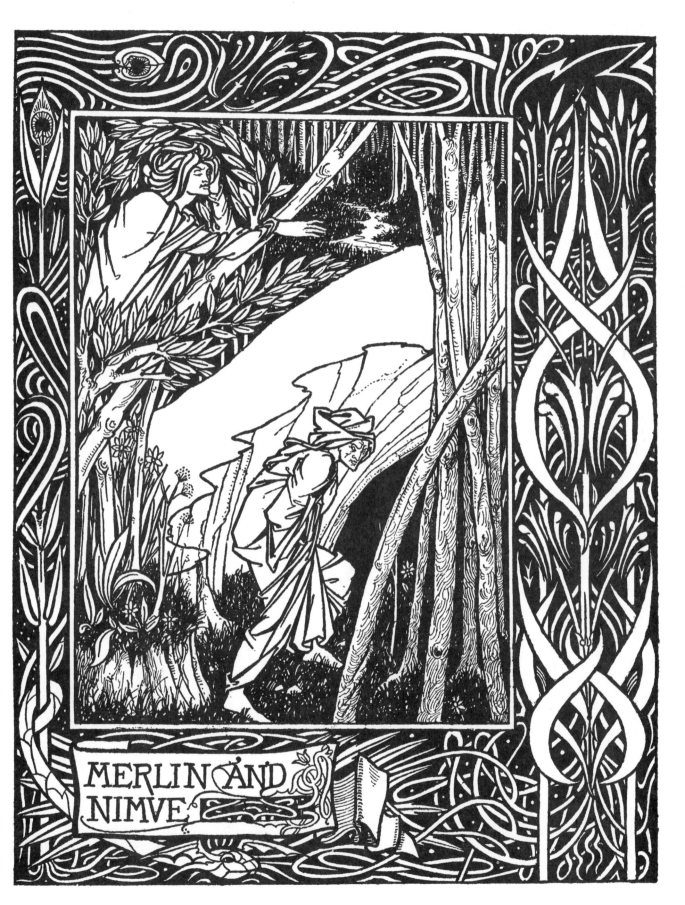

MERLIN AND NIMVE

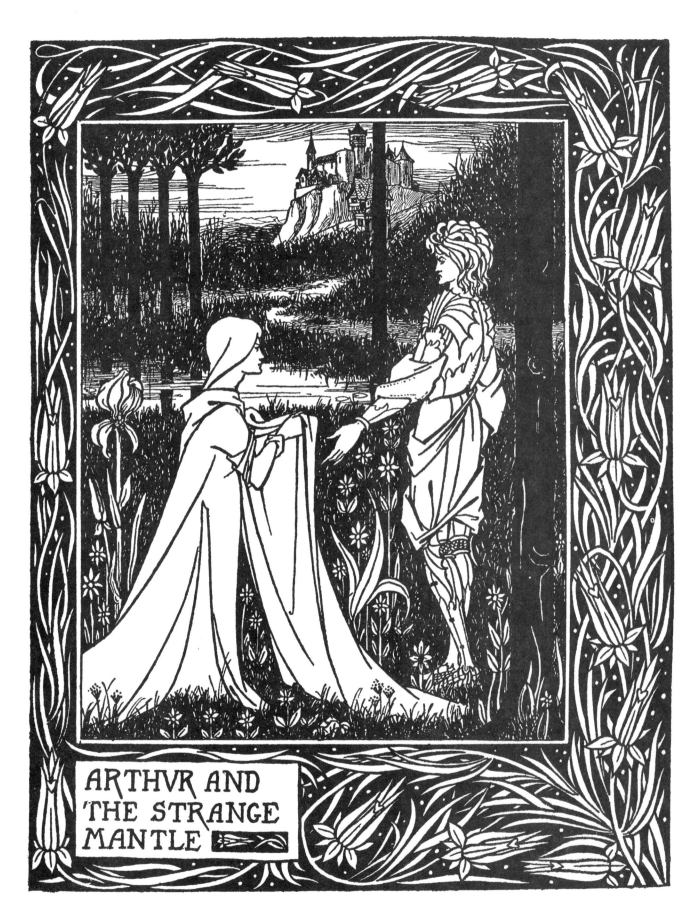

ARTHVR AND THE STRANGE MANTLE

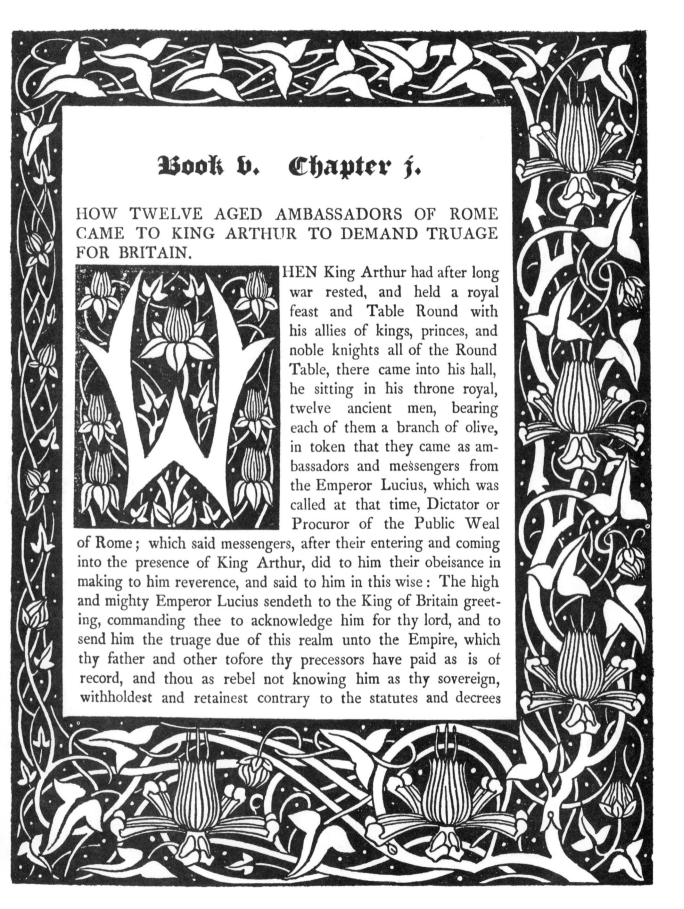

Book v. Chapter j.

HOW TWELVE AGED AMBASSADORS OF ROME CAME TO KING ARTHUR TO DEMAND TRUAGE FOR BRITAIN.

HEN King Arthur had after long war rested, and held a royal feast and Table Round with his allies of kings, princes, and noble knights all of the Round Table, there came into his hall, he sitting in his throne royal, twelve ancient men, bearing each of them a branch of olive, in token that they came as ambassadors and messengers from the Emperor Lucius, which was called at that time, Dictator or Procuror of the Public Weal of Rome; which said messengers, after their entering and coming into the presence of King Arthur, did to him their obeisance in making to him reverence, and said to him in this wise: The high and mighty Emperor Lucius sendeth to the King of Britain greeting, commanding thee to acknowledge him for thy lord, and to send him the truage due of this realm unto the Empire, which thy father and other tofore thy precessors have paid as is of record, and thou as rebel not knowing him as thy sovereign, withholdest and retainest contrary to the statutes and decrees

Book vj. Chapter j.

HOW SIR LAUNCELOT AND SIR LIONEL DEPARTED FROM THE COURT, AND HOW SIR LIONEL LEFT HIM SLEEPING AND WAS TAKEN.

SOON after that King Arthur was come from Rome into England, then all the knights of the Table Round resorted unto the king, and made many jousts and tournaments, and some there were that were but knights, which increased so in arms and worship that they passed all their fellows in prowess and noble deeds, and that was well proved on many; but in especial it was proved on Sir Launcelot du Lake, for in all tournaments and jousts and deeds of arms, both for life and death, he passed all other knights, and at no time he was never overcome but if it were by treason or enchantment, so Sir Launcelot increased so marvellously in worship, and in honour, therefore is he the first knight that the French book maketh mention of after King Arthur came from Rome. Wherefore Queen Guenever had him in great favour above all other knights, and in certain he loved the queen again above all

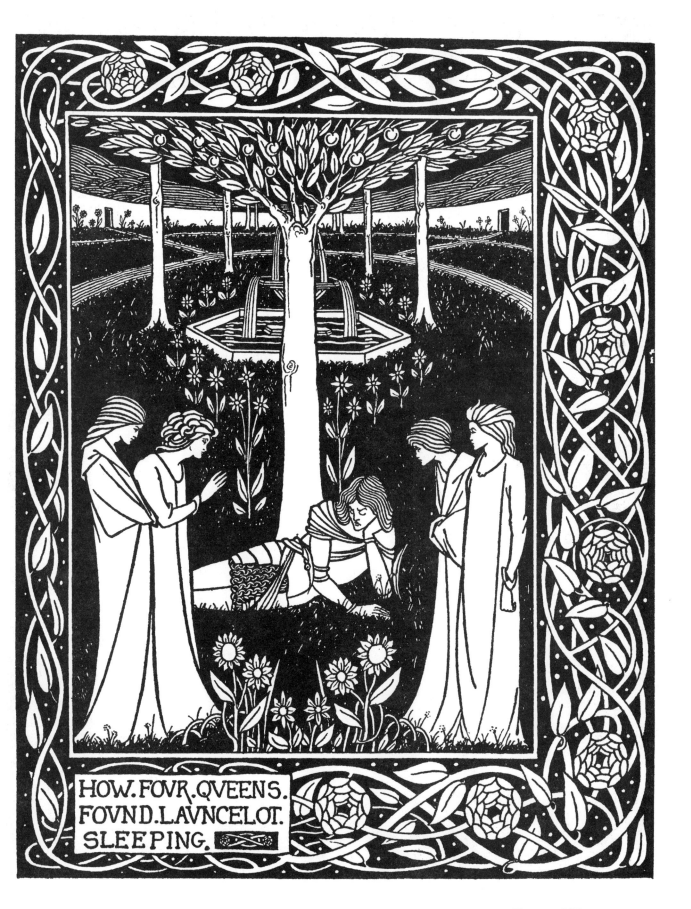

HOW. FOVR. QVEENS.
FOVND. LAVNCELOT.
SLEEPING.

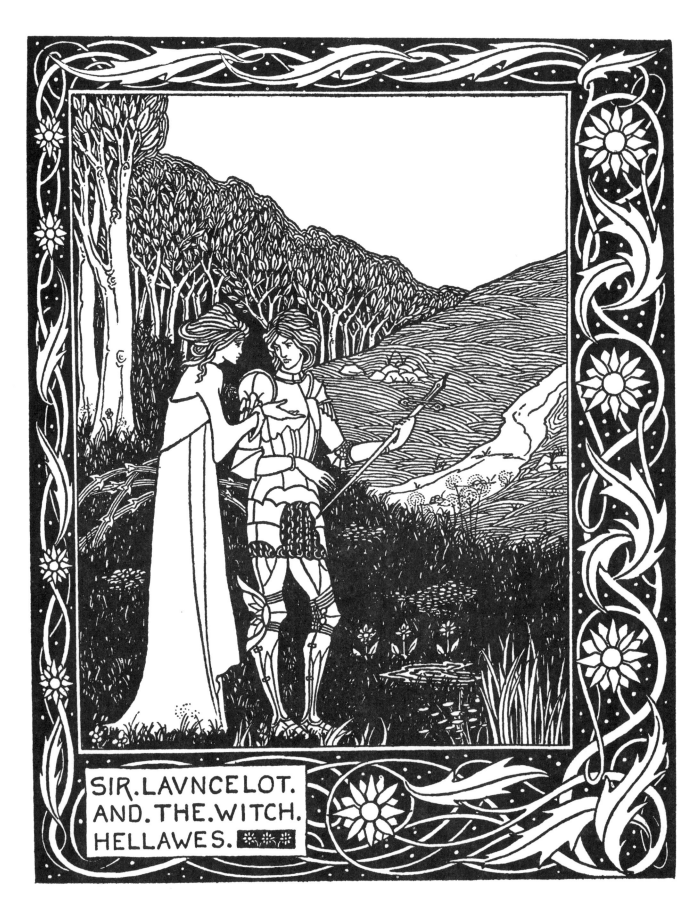

SIR. LAVNCELOT.
AND. THE. WITCH.
HELLAWES. ✱✱✱

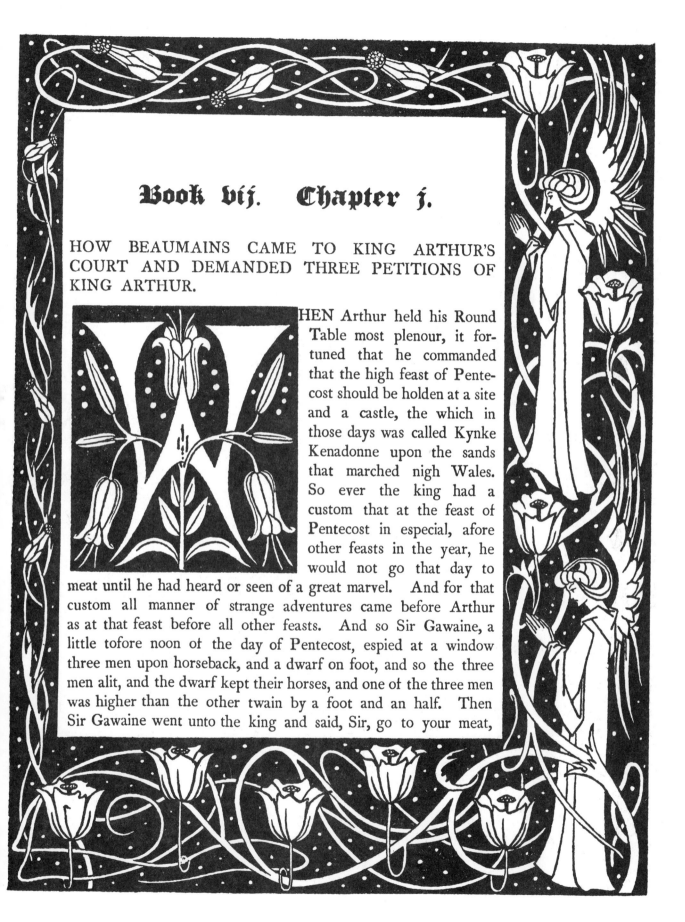

Book vij. Chapter j.

HOW BEAUMAINS CAME TO KING ARTHUR'S COURT AND DEMANDED THREE PETITIONS OF KING ARTHUR.

WHEN Arthur held his Round Table most plenour, it fortuned that he commanded that the high feast of Pentecost should be holden at a site and a castle, the which in those days was called Kynke Kenadonne upon the sands that marched nigh Wales. So ever the king had a custom that at the feast of Pentecost in especial, afore other feasts in the year, he would not go that day to meat until he had heard or seen of a great marvel. And for that custom all manner of strange adventures came before Arthur as at that feast before all other feasts. And so Sir Gawaine, a little tofore noon of the day of Pentecost, espied at a window three men upon horseback, and a dwarf on foot, and so the three men alit, and the dwarf kept their horses, and one of the three men was higher than the other twain by a foot and an half. Then Sir Gawaine went unto the king and said, Sir, go to your meat,

𝕭𝖔𝖔𝖐 𝖛𝖎𝖎𝖏. 𝕮𝖍𝖆𝖕𝖙𝖊𝖗 𝖏.

HOW SIR TRISTRAM DE LIONES WAS BORN, AND HOW HIS MOTHER DIED AT HIS BIRTH, WHEREFORE SHE NAMED HIM TRISTRAM.

IT was a king that hight Meliodas, and he was lord and king of the country of Liones, and this Meliodas was a likely knight as any was that time living. And by fortune he wedded King Mark's sister of Cornwall; and she was called Elizabeth, that was called both good and fair. And at that time King Arthur reigned, and he was whole king of England, Wales, and Scotland, and of many other realms: howbeit there were many kings that were lords of many countries, but all they held their lands of King Arthur; for in Wales were two kings, and in the north were many kings; and in Cornwall and in the west were two kings; also in Ireland were two or three kings, and all were under the obeissance of King Arthur. So was the King of France, and the King of Brittany, and all the lordships unto Rome. So when this King Meliodas had been with his wife, within a while she waxed great with child, and she was a full meek lady, and well she loved her lord, and he her again, so there was great joy betwixt them. Then there was a lady in that country that had loved King Meliodas long, and by no mean she never could get his love;

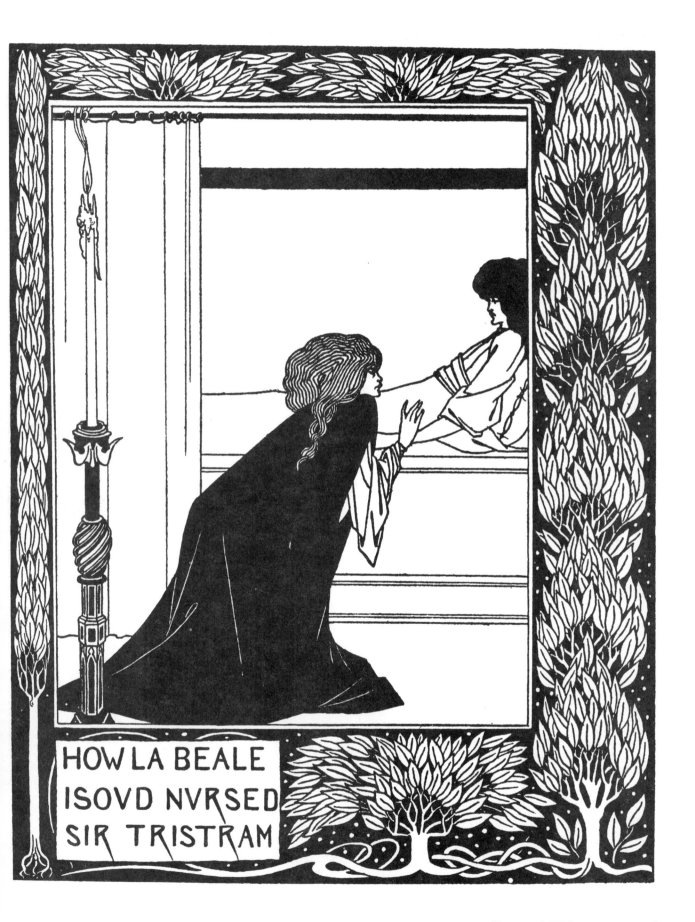

HOW LA BEALE
ISOVD NVRSED
SIR TRISTRAM

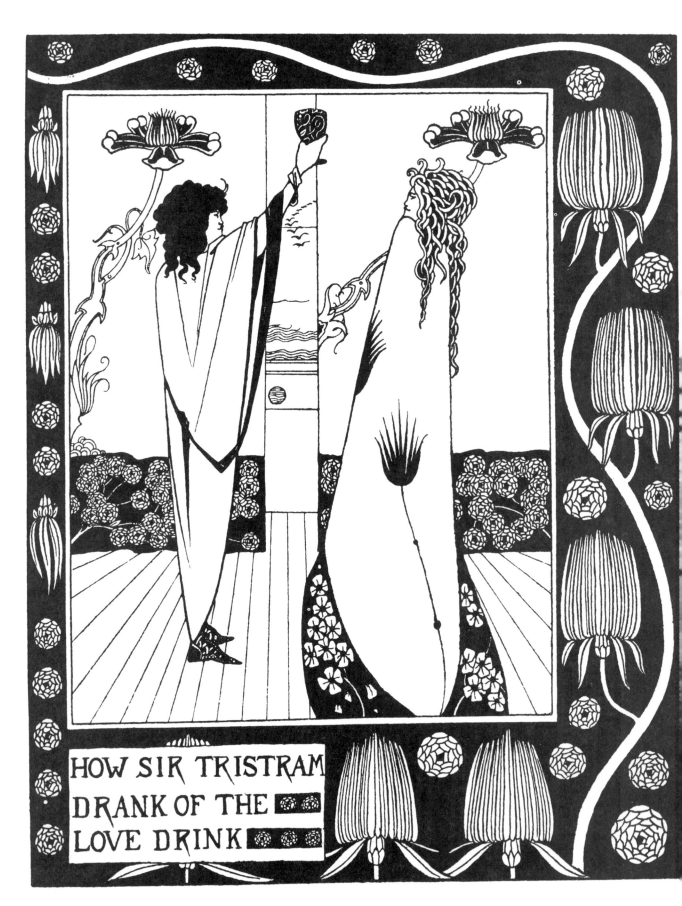

HOW SIR TRISTRAM DRANK OF THE LOVE DRINK

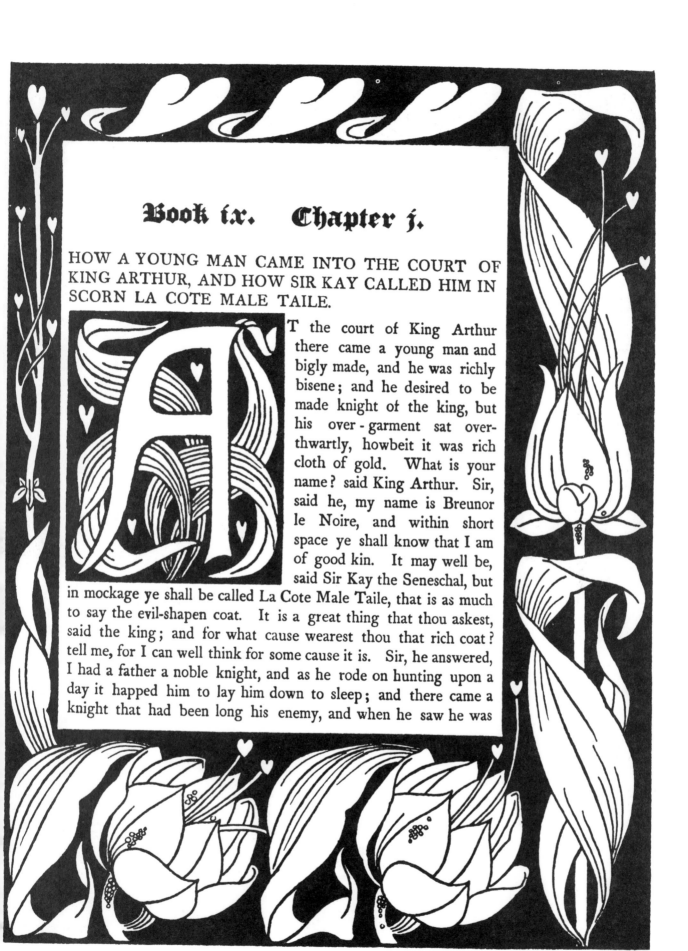

Book ix. Chapter j.

HOW A YOUNG MAN CAME INTO THE COURT OF KING ARTHUR, AND HOW SIR KAY CALLED HIM IN SCORN LA COTE MALE TAILE.

AT the court of King Arthur there came a young man and bigly made, and he was richly bisene; and he desired to be made knight of the king, but his over-garment sat overthwartly, howbeit it was rich cloth of gold. What is your name? said King Arthur. Sir, said he, my name is Breunor le Noire, and within short space ye shall know that I am of good kin. It may well be, said Sir Kay the Seneschal, but in mockage ye shall be called La Cote Male Taile, that is as much to say the evil-shapen coat. It is a great thing that thou askest, said the king; and for what cause wearest thou that rich coat? tell me, for I can well think for some cause it is. Sir, he answered, I had a father a noble knight, and as he rode on hunting upon a day it happed him to lay him down to sleep; and there came a knight that had been long his enemy, and when he saw he was

HOW LA BEALE
ISOVD WROTE TO
SIR TRISTRAM

HOW KING
MARKE FOVND
SIR TRISTRAM

HOW. MORGAN.LE
FAY. GAVE. A. SHIELD.
TO. SIR. TRISTRAM

Book x. Chapter j.

HOW SIR TRISTRAM JOUSTED, AND SMOTE
DOWN KING ARTHUR, BECAUSE HE TOLD HIM
NOT THE CAUSE WHY HE BARE THAT SHIELD.

AND if so be ye can descrive what ye bear, ye are worthy to bear the arms. As for that, said Sir Tristram, I will answer you, this shield was given me, not desired, of Queen Morgan le Fay; and as for me, I can not descrive these arms, for it is no point of my charge, and yet I trust to God to bear them with worship. Truly, said King Arthur, ye ought not to bear none arms but if ye wist what ye bear: but I pray you tell me your name. To what intent, said Sir Tristram? For I would wit, said Arthur. Sir, ye shall not wit as at this time. Then shall ye and I do battle together, said King Arthur. Why, said Sir Tristram, will ye do battle with me but if I tell you my name? and that little needeth you an ye were a man of worship, for ye have seen me this day have had great travail, and therefore ye

How King Mark and Sir Dinadan heard Sir Palomides

making great sorrow and mourning for La Beale Isoud.

La Beale Isoud at Joyous Gard.

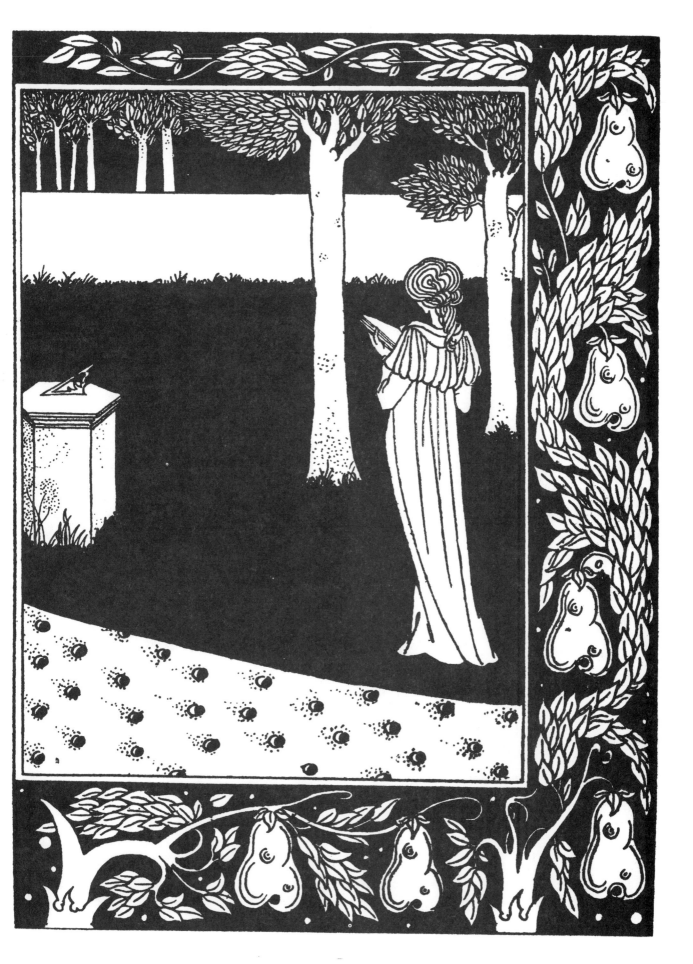

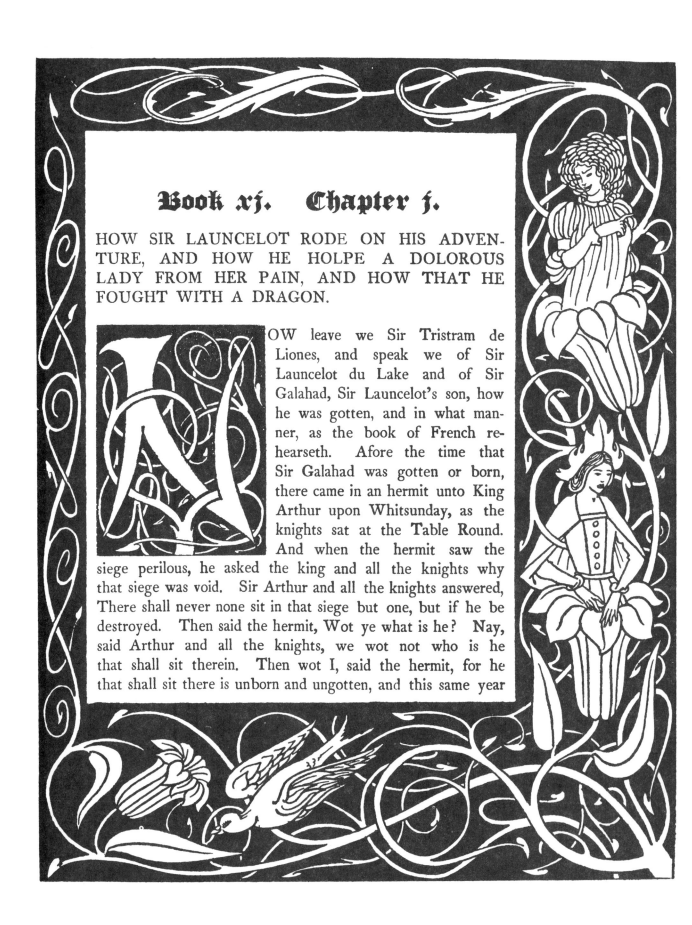

Book xj. Chapter j.

HOW SIR LAUNCELOT RODE ON HIS ADVEN-
TURE, AND HOW HE HOLPE A DOLOROUS
LADY FROM HER PAIN, AND HOW THAT HE
FOUGHT WITH A DRAGON.

NOW leave we Sir Tristram de Liones, and speak we of Sir Launcelot du Lake and of Sir Galahad, Sir Launcelot's son, how he was gotten, and in what manner, as the book of French rehearseth. Afore the time that Sir Galahad was gotten or born, there came in an hermit unto King Arthur upon Whitsunday, as the knights sat at the Table Round. And when the hermit saw the siege perilous, he asked the king and all the knights why that siege was void. Sir Arthur and all the knights answered, There shall never none sit in that siege but one, but if he be destroyed. Then said the hermit, Wot ye what is he? Nay, said Arthur and all the knights, we wot not who is he that shall sit therein. Then wot I, said the hermit, for he that shall sit there is unborn and ungotten, and this same year

𝕭𝖔𝖔𝖐 𝖝𝖎𝖏. 𝕮𝖍𝖆𝖕𝖙𝖊𝖗 𝖏.

HOW SIR LAUNCELOT IN HIS MADNESS TOOK A
SWORD AND FOUGHT WITH A KNIGHT, AND LEAPT
IN A BED.

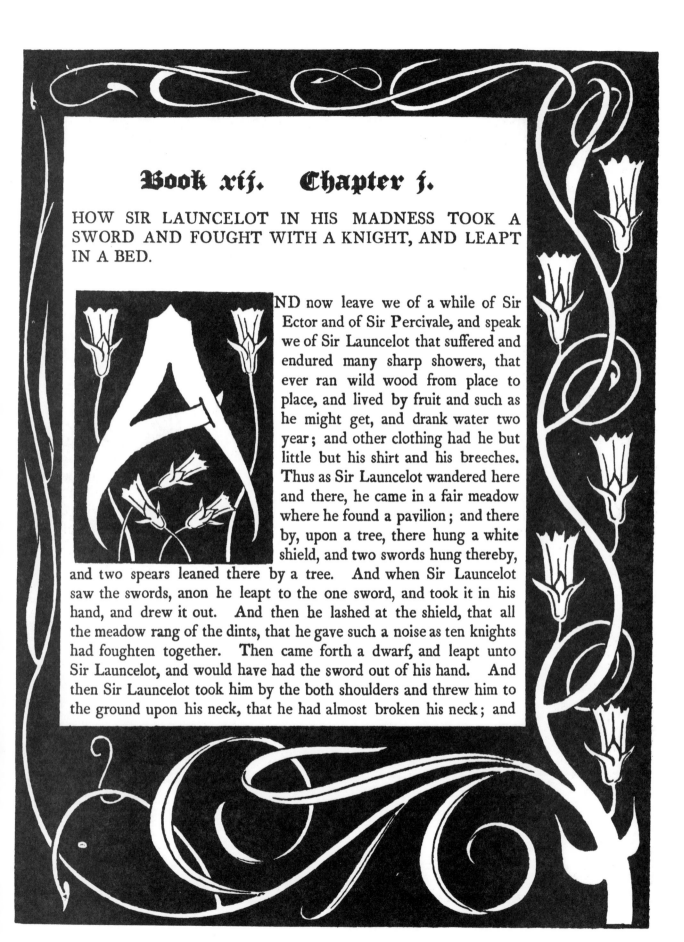

AND now leave we of a while of Sir
Ector and of Sir Percivale, and speak
we of Sir Launcelot that suffered and
endured many sharp showers, that
ever ran wild wood from place to
place, and lived by fruit and such as
he might get, and drank water two
year; and other clothing had he but
little but his shirt and his breeches.
Thus as Sir Launcelot wandered here
and there, he came in a fair meadow
where he found a pavilion; and there
by, upon a tree, there hung a white
shield, and two swords hung thereby,
and two spears leaned there by a tree. And when Sir Launcelot
saw the swords, anon he leapt to the one sword, and took it in his
hand, and drew it out. And then he lashed at the shield, that all
the meadow rang of the dints, that he gave such a noise as ten knights
had foughten together. Then came forth a dwarf, and leapt unto
Sir Launcelot, and would have had the sword out of his hand. And
then Sir Launcelot took him by the both shoulders and threw him to
the ground upon his neck, that he had almost broken his neck; and

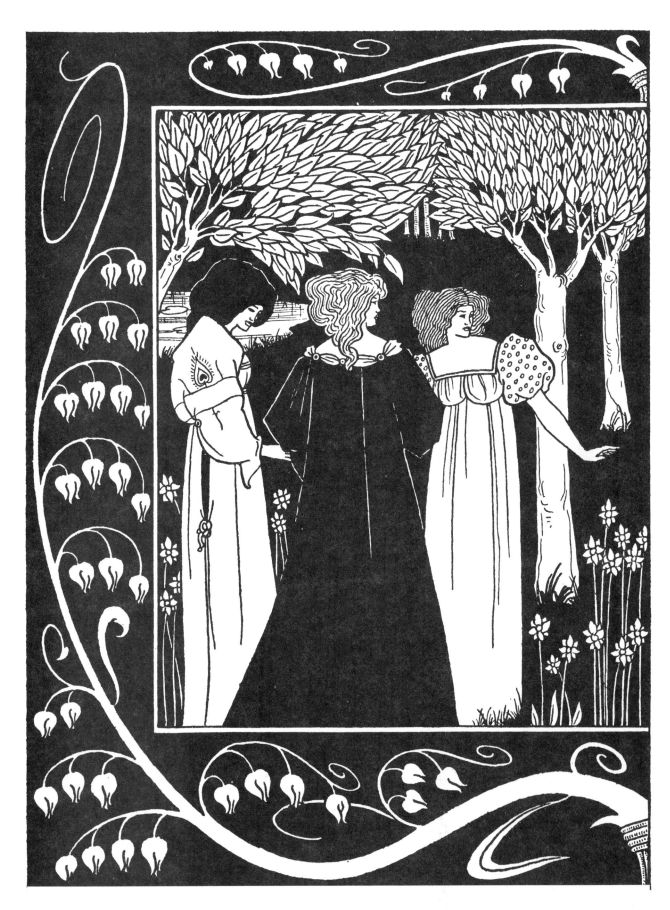

How Sir Launcelot was known by Dame Elaine.

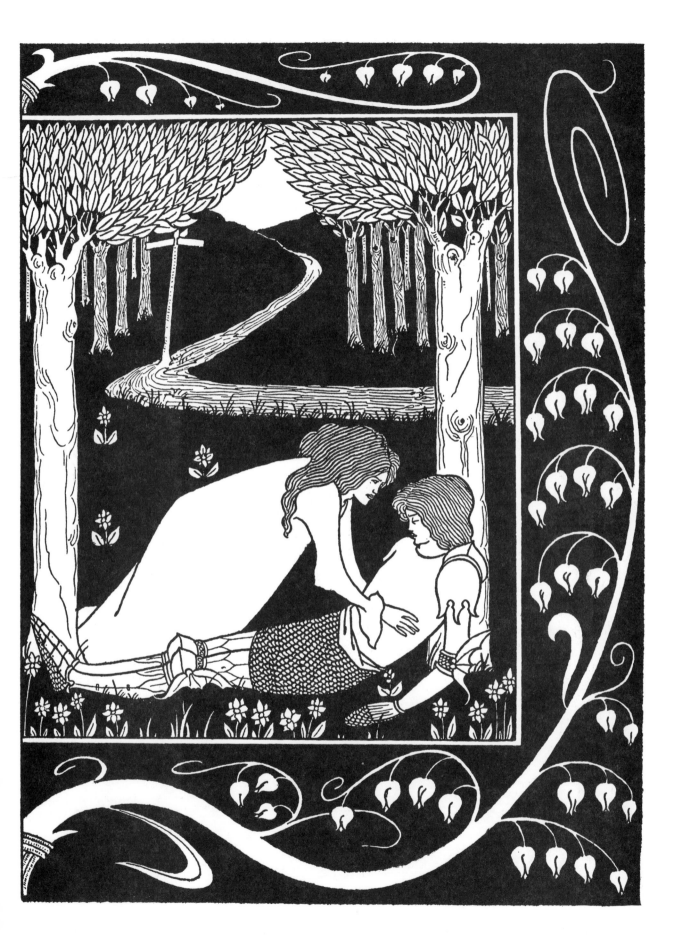

Book xiij.　Chapter j.

HOW AT THE VIGIL OF THE FEAST OF PENTECOST ENTERED INTO THE HALL BEFORE KING ARTHUR A DAMOSEL, AND DESIRED SIR LAUNCELOT FOR TO COME AND DUB A KNIGHT, AND HOW HE WENT WITH HER.

T the vigil of Pentecost, when all the fellowship of the Round Table were come unto Camelot, and there heard their service, and the tables were set ready to the meat, right so entered into the hall a full fair gentlewoman on horseback, that had ridden full fast, for her horse was all besweated. Then she there alit, and came before the king and saluted him; and he said, Damosel, God thee bless. Sir, said she, for God's sake say me where Sir Launcelot is. Yonder ye may see him, said the king. Then she went unto Launcelot and said, Sir Launcelot, I salute you on King Pelles' behalf, and I require you come on with me hereby into a forest. Then Sir Launcelot asked her with whom she dwelled. I dwell, said she, with King Pelles. What will ye with me? said Launcelot. Ye shall know, said she, when ye come thither. Well, said he, I will

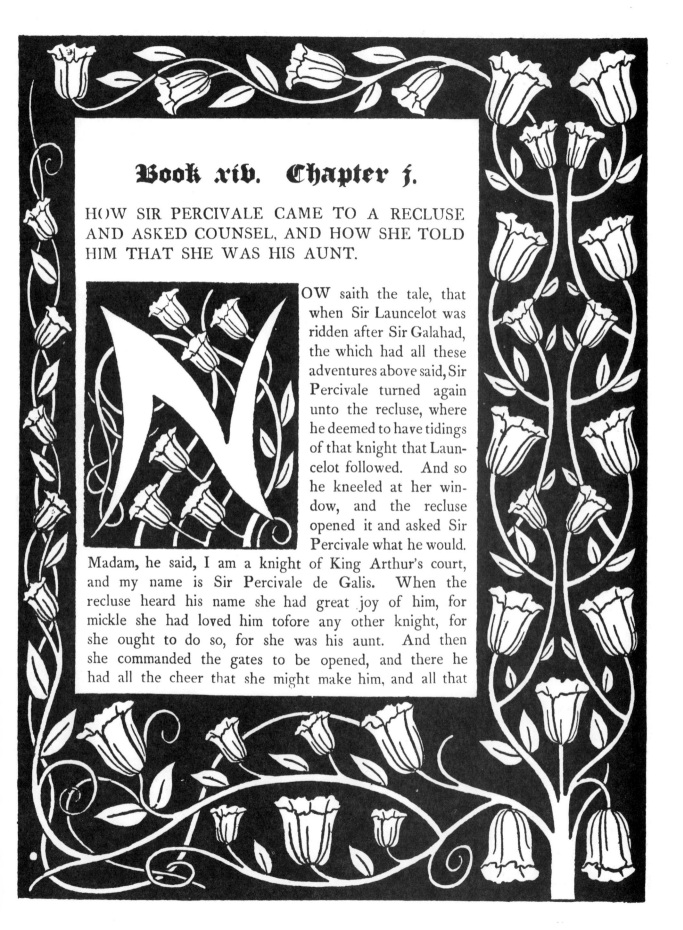

Book xiv. Chapter j.

HOW SIR PERCIVALE CAME TO A RECLUSE AND ASKED COUNSEL, AND HOW SHE TOLD HIM THAT SHE WAS HIS AUNT.

NOW saith the tale, that when Sir Launcelot was ridden after Sir Galahad, the which had all these adventures above said, Sir Percivale turned again unto the recluse, where he deemed to have tidings of that knight that Launcelot followed. And so he kneeled at her window, and the recluse opened it and asked Sir Percivale what he would. Madam, he said, I am a knight of King Arthur's court, and my name is Sir Percivale de Galis. When the recluse heard his name she had great joy of him, for mickle she had loved him tofore any other knight, for she ought to do so, for she was his aunt. And then she commanded the gates to be opened, and there he had all the cheer that she might make him, and all that

Book xv. Chapter j.

HOW SIR LAUNCELOT CAME TO A CHAPEL, WHERE HE FOUND DEAD, IN A WHITE SHIRT, A MAN OF RELIGION, OF AN HUNDRED WINTER OLD.

HEN the hermit had kept Sir Launcelot three days, the hermit gat him an horse, an helm, and a sword. And then he departed about the hour of noon. And then he saw a little house. And when he came near he saw a chapel, and there beside he saw an old man that was clothed all in white full richly; and then Sir Launcelot said, God save you. God keep you, said the good man, and make you a good knight. Then Sir Launcelot alit and entered into the chapel, and there he saw an old man dead, in a white shirt of passing fine cloth. Sir, said the good man, this man that is dead ought not to be in such clothing as ye see him in, for in that he brake the oath of his order, for he hath been more

Book xvj. Chapter j.

HOW SIR GAWAINE WAS NIGH WEARY OF THE QUEST OF THE SANGREAL, AND OF HIS MARVELLOUS DREAM.

HEN Sir Gawaine was departed from his fellowship he rode long without any adventure. For he found not the tenth part of adventure as he was wont to do. For Sir Gawaine rode from Whitsuntide until Michaelmas and found none adventure that pleased him. So on a day it befel Gawaine met with Sir Ector de Maris, and either made great joy of other that it were marvel to tell. And so they told every each other, and complained them greatly that they could find none adventure. Truly, said Sir Gawaine unto Sir Ector, I am nigh weary of this quest, and loth I am to follow further in strange countries. One thing marvelled me, said Sir Ector, I have met with twenty knights, fellows of mine, and all they complain as I do. I have marvel, said Sir Gawaine, where that Sir Launcelot your brother is. Truly, said Sir Ector,

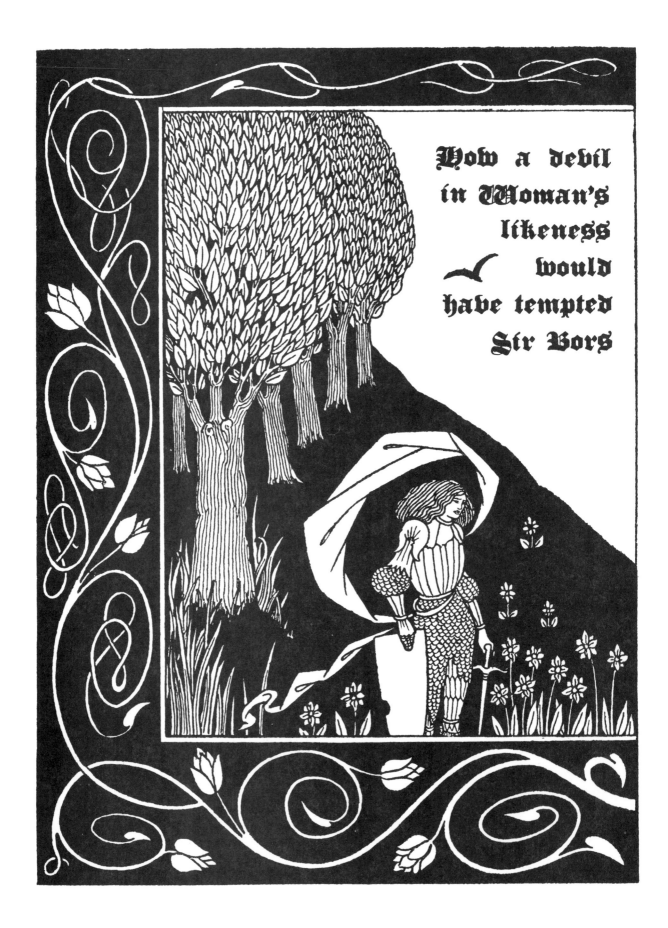

How a devil in Woman's likeness would have tempted Sir Bors

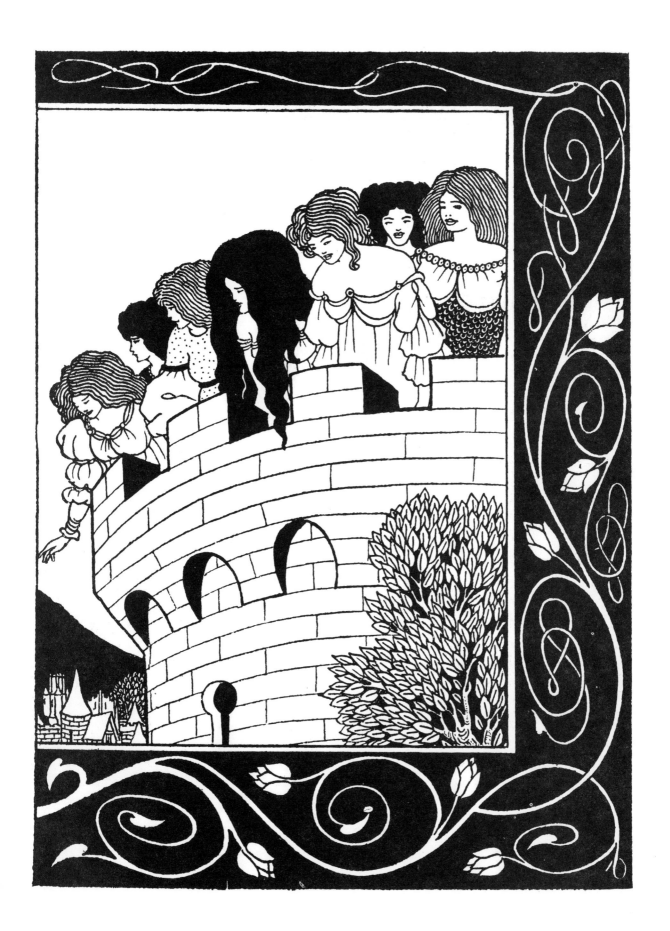

Book xvij. Chapter j.

HOW SIR GALAHAD FOUGHT AT A TOURNA-
MENT, AND HOW HE WAS KNOWN OF SIR
GAWAINE AND SIR ECTOR DE MARIS.

OW saith this story, when Galahad had rescued Perci-vale from the twenty knights he yede then into a waste forest wherein he rode many journeys; and he found many adventures the which he brought to an end, whereof the story maketh here no mention. Then he took his way to the sea on a day and it befel as he passed by a castle where was a wonder tournament, but they without had done so much that they within were put to the worse, yet were they within good knights enough. When Galahad saw that those within were at so great a mischief that men slew them at the entry of the castle, then he thought to help them, and put a spear forth and smote the first that he fell to the earth, and the spear brake to pieces. Then he

Book xviij. Chapter j.

OF THE JOY OF KING ARTHUR AND THE
QUEEN HAD OF THE ACHIEVEMENT OF THE
SANGREAL; AND HOW LAUNCELOT FELL TO
HIS OLD LOVE AGAIN.

SO after the quest of the Sangreal was fulfilled, and all knights that were left on live were come again unto the Table Round, as the book of the Sangreal maketh mention, then was there great joy in the court; and in especial King Arthur and Queen Guenever made great joy of the remnant that were come home, and passing glad was the king and the queen of Sir Launcelot and of Sir Bors, for they had been passing long away in the quest of the Sangreal. Then, as the book saith, Sir Launcelot began to resort unto Queen Guenever again, and forgat the promise and the perfection that he made in the quest. For, as the book saith, had not Sir Launcelot been in his privy thoughts and in his mind so set inwardly

How Queen Guenever rode on Maying.

Book xix. Chapter j.

HOW QUEEN GUENEVER RODE ON MAYING WITH CERTAIN KNIGHTS OF THE ROUND TABLE AND CLAD ALL IN GREEN.

SO it befell in the month of May, Queen Guenever called unto her, knights of the Table Round; and she gave them warning that early upon the morrow she would ride on Maying into woods and fields beside Westminster. And I warn you that there be none of you but that he be well horsed, and that ye all be clothed in green, either in silk outher in cloth; and I shall bring with me ten ladies, and every knight shall have a lady behind him, and every knight shall have a squire and two yeomen; and I will that ye all be well horsed. So they made them ready in the freshest manner. And these were the names of the knights: Sir Kay le Seneschal, Sir Agravaine, Sir Brandiles, Sir Sagramore le

Book xx. Chapter j.

HOW SIR AGRAVAINE AND SIR MORDRED WERE BUSY UPON SIR GAWAINE FOR TO DISCLOSE THE LOVE BETWEEN SIR LAUNCELOT AND QUEEN GUENEVER.

IN May when every lusty heart flourisheth and bourgeoneth, for as the season is lusty to behold and comfortable, so man and woman rejoice and gladden of summer coming with his fresh flowers: for winter with his rough winds and blasts causeth a lusty man and woman to cower, and sit fast by the fire. So in this season, as in the month of May, it befell a great anger and unhap that stinted not till the flower of chivalry of all the world was destroyed and slain; and all was long upon two unhappy knights, the which were named Agravaine and Sir Mordred, that were brethren unto Sir Gawaine. For this Sir Agravaine and Sir Mordred had ever a privy hate unto the queen Dame Guenever and to Sir Launcelot, and daily and nightly they ever watched upon Sir Launcelot.

Book xxj. Chapter j.

HOW SIR MORDRED PRESUMED AND TOOK ON HIM TO BE KING OF ENGLAND, AND WOULD HAVE MARRIED THE QUEEN, HIS UNCLE'S WIFE.

AS Sir Mordred was ruler of all England, he did do make letters as though that they came from beyond the sea, and the letters specified that King Arthur was slain in battle with Sir Launcelot. Wherefore Sir Mordred made a parliament, and called the lords together, and there he made them to choose him king; and so was he crowned at Canterbury, and held a feast there fifteen days; and afterward he drew him unto Winchester, and there he took the Queen Guenever, and said plainly that he would wed her which was his uncle's wife, and his father's wife. And so he made ready for the feast, and a day prefixed that they should be wedded; wherefore Queen Guenever was passing heavy. But she durst

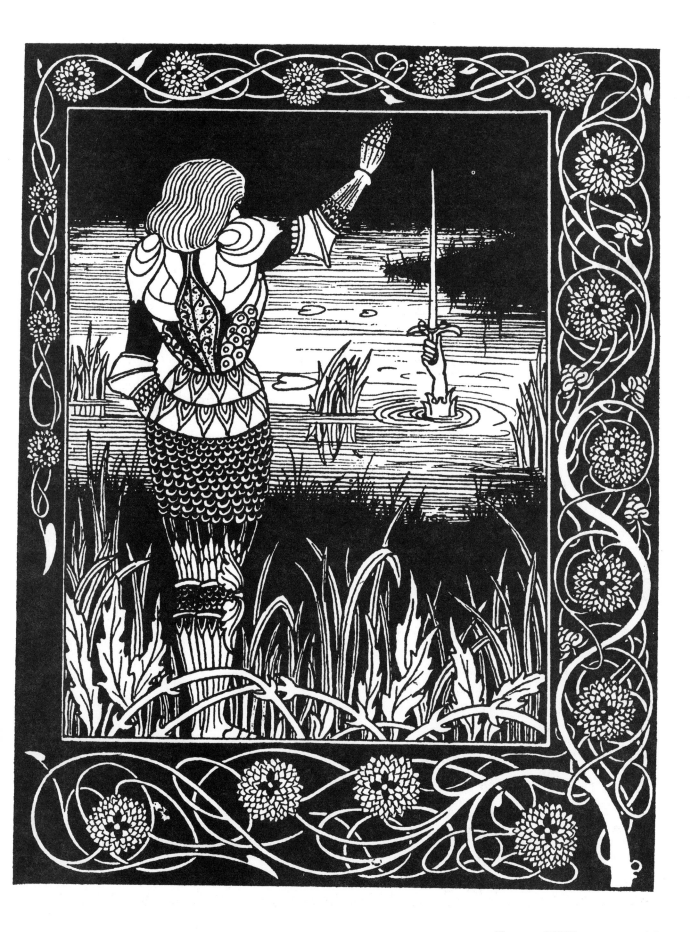

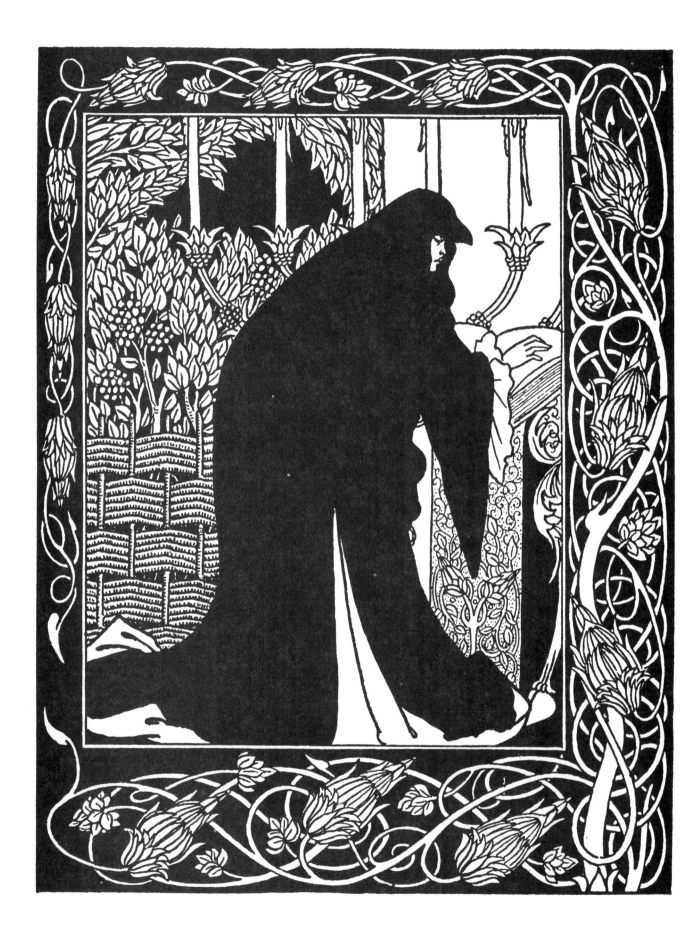